ENCOUNTERS WITH GOD

ENCOUNTERS WITH GOD

In Quest of the
Ancient Icons of Mary

Sister Wendy Beckett

Continuum
The Tower Building
11 York Road
London SE1 7NX

Suite 704, 80 Maiden Lane
New York
NY 10038, USA

www.continuumbooks.com
© Sister Wendy Beckett, 2009

First published in hardback 2009.

British Library Cataloguing-in-Publication Data
A catalogue record for this book is available from the British Library.

ISBN 978 08264 4178 2

Designed and typeset by Benn Linfield
Printed and bound in Great Britain by Ashford Press

*This book is dedicated
with love and gratitude
to Fr Stephen Blair
without whom it would not exist*

I

This book is an attempt to share with you an extraordinary discovery.

As Christians, we know that our faith is not an abstract belief but it is a deep and loving relationship with the father of Jesus. Relationships by their very nature develop and change, and offer us discoveries about ourselves and about the One we love. Prayer is the relationship of discoveries, of new insights of astonishing realizations that can change the way we live. Usually, God does not reveal Himself in extraordinary manifestations of power or even light. He comes gently, drawing us deeper and deeper into His own truth. What we discover of course is that His truth is our truth. We are fully ourselves to the extent that we have fully surrendered to our beloved Lord.

I am privileged to lead a life of prayer and so discoveries at relative depths are part of my routine, one could say, yet this is the

first time that I have been so bowled over by a discovery that I have felt an urgent need to share it with other people. I do not think we can share pure prayer. It is shared in that all God gives He gives for everybody, never for the single individual. So this is a discovery of reflected prayer, an encounter with God in a form I did not expect.

'Encounter' is a dramatic word. Encounters with God can be so undramatic that we hardly notice them until they have come and gone. It is then that we may notice and then our life, if it is a true encounter, begins to change. I have lived close to God all my life, obviously through no virtue of my own, and encounter is not a word that I would normally use for how He reveals Himself to me. Of course, He reveals Himself in everything if we are attentive to Him. But what I want to share I think deserves the word 'encounter'. It is unique in my life and a privilege that I cannot bear to keep hidden.

If I say that this discovery is about the beauty of icons, I am saying both too much and too little, because I am not speaking about icons in general, which are already fairly well known, but

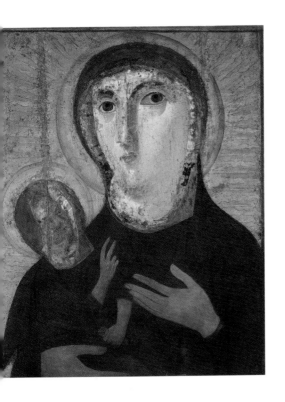 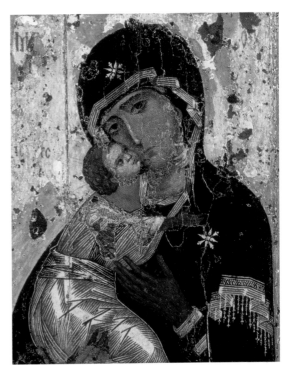

about one particular kind of icon, the very earliest that still sur-
vives. And here too, of the roughly fifty-three in existence, I am
engaged only with the eight surviving icons of Mary, the Mother
of God. They are very different from all we think of as icons of the
Virgin. Take any one of these eight — say, the icon of Santa Maria
Nova in Rome [above left] — and lay it beside one of the best
loved of our familiar icons, the *Virgin of Vladimir* [above right]. The

contrast is almost shocking. The seventh-century Virgin in her battered beauty comes from the imagination of early Christianity. The lovely *Virgin of Vladimir*, dated to about 1131, speaks to us from our own sad times, even over almost a millenium. This is a Byzantine icon, with all its magnificent theology, its weight of history, its certainty of devotional meaning. The seventh-century Virgin comes to us from a time close to that of Christ, when faith was still alive with wonder, and possibilities were infinite.

These eight icons of the Virgin are deeply human and I think we can read into them what we know of gospel history. Jesus will be killed, rejected by us, His brothers and sisters. Mary will grieve. But the early Christians were more concerned with the wonder of Christ's coming than of the pain it would mean to Him. This becomes a theme in the Middle Ages when so much Christian art calls for us to grieve with Jesus and His mother. But there are no pietas in the first century; there is the Saviour Child and His quiet, humble mother.

What astonished and distressed me was to find that these early icons and their profundity of spiritual power, are almost unknown.

I have travelled to see all eight, a pilgrimage of desire, and what I was privileged to see, I would love for you to see too. To see these icons more clearly though, we need to see them in their context. That context, of course, is early Christian art.

II

The early Christians can seem deceptively similar to ourselves. We share the same faith. They lived their faith, however, in a world almost inconceivably unlike our own. This was a society in which slavery was completely taken for granted, in which a father had life and death power over his children, in which 90 per cent of the populace was illiterate and information came from hearing. Our Christian ancestors died for their faith, but how few they had of the supports we take as a matter of course. We have the creed, over which theologians for centuries have been working and refining. Our worship is centred, as theirs was, on the Eucharistic sacrifice, the re-enactment of the Last Supper, and we have all, like them, received the Sacrament of Baptism. The other Sacraments, and the whole structure of the church with its parish, parish priest, buildings and organization, had not yet become formalized. Above all, we have the unfailing illumination of the New Testament.

It comes with a jolt to realize that it was not until the beginning of the third century that the Church came to a general agreement that there were only four gospels. Swirling around the life of the early Christian, were many 'gospels'. One can imagine their confusion as they tried to integrate the deep simplicity and power of the true 'gospels' (those of St Mark, St Matthew, St Luke and St John) with the perplexing sayings of the spiritual writings that offered themselves as equally authentic. For example, the gospel of St Thomas has Jesus saying, 'Every woman who will make herself male will enter the Kingdom of Heaven', with its frightening implications for a woman who is quite content to remain female. Is heaven closed to her? The same gospel has Simon Peter saying, 'Women are not worthy of life'. The gospel of Philip tells us, 'God is a man eater', and the proto-gospel of James has the extraordinary story of the birth of Jesus, describing the doubts of the midwife Salome. She insists on inserting her finger 'to examine Mary's condition', and her hand withers away: 'see my hand is burning, falling away from me'. It is only touching the Child that brings a cure. Unfortunately, this story greatly took the

Christian imagination and was repeated, visually, for centuries. Even worse is the infancy gospel of Thomas, which has the child Jesus cursing those who displease Him, and has poor St Joseph 'smitten with grief'. He has to order Mary, 'Do not let him out the door for those who anger Him die.'

Few of these stories, and only some of the sayings attributed to Jesus, make any Christian sense, yet for over two hundred years converts to the new faith, aflame with gratitude to the saving power of God, had to grapple with these inconsistencies. It was only toward the end of the fourth century, in 367, that St Athanasius the Great, Bishop of Alexandria, could bear it no longer, and issued his famous 39th Festal Letter. This, as far as was in his power, settled once and for all which were the twenty-seven books that made up the New Testament, 'the canon'. Even despite his enormous authority, one or two books drifted in and out of the canon over the years to come – the Revelations of St John, for example, and the great epistle to the Hebrews. It could be that the early readers of Hebrews were disturbed by its vivid awareness of Christ's humanity, 'his tears and entreaties', which is precisely what we find

so moving and helpful. The early church shrank from the reality of the Passion, and it took many centuries before they could bring themselves to depict the crucifixion.

III

When we say St Athanasius issued his great letter, our instinct is to think of present day communications. But, at the end of the fourth century, even the weightiest pronouncement of churchmen travelled slowly and with difficulty. Christians in Egypt might have received the welcome news in a year or so, but think of those in distant parts of the empire, dependent on the vagaries of messengers and the uncertainties of travel. Eventually, of course, these blessed certainties were known to all, but they were not there in full force to support our early Christians.

True, they believed what we believe, but so much of the faith was still in embryo. For us, who understand our religion in all its prayerful depths and subtlety, it can come with a refreshing astonishment to see how simply the early Christians were converted. 'What must I do to be saved?', asks the anguished Jew or pagan. 'Believe in the Lord Jesus and be baptized', answers the

evangelist. In other words, believe that Christianity is a relationship religion (accepting Jesus means entering into the mystery of His Sonship with the Father), and it is a religion of action: baptism takes us into the Church which supports us in the acts of love which are of the essence of faith.

When Cornelius seeks enlightenment from Peter, it takes Peter not much more than one hundred words, in an English translation, to give him a mini-gospel, which ends, 'everyone who believes in Him has forgiveness of sins through His name'. We are told, 'he had not finished these words when the Holy Spirit descended upon all who were listening to Peter's message …'. They were immediately baptized in the name of Jesus Christ (Acts 10.34–44). We find the same powerful immediacy in the story of Philip and the eunuch. This man, an Ethiopian court official, the treasurer of an Ethiopian Queen, had made a pilgrimage to Jerusalem in search of God. He meets Philip who explains to him 'the Good News of Jesus'. The official in his chariot is journeying through the desert to Gaza. By the time they have come to an oasis, the eunuch has understood the 'good news'. 'There is water

here, what is to keep me from being baptized?' Obviously, there is nothing. The chariot stops, Philip goes down into the pool and the eunuch is baptized. This man has no text, no gospel and no illuminating epistles from St Paul. He has the unadorned Good News that Philip gives him (Acts 9.26–38). For one who hungers for God, this is apparently enough. One imagines the Ethiopian aged and honoured, living out his life at court, inexhaustibly meditating on the liberating truths that Philip had revealed to him.

The actual core of Christianity is very simple and very deep. It is there for those who want it. Looking at the long list of early Christian martyrs who had so little to support them, one realizes how transforming every word of the gospel could be. It is as if they held to their hearts the acorn, whereas we live under the shade of the oak tree.

IV

For the first two hundred years there seems to have been no Christian art at all. If there was, all trace has vanished. Historians used to explain, with confidence, that this was only to be expected. Not only were the Christians poor and scattered, they lived under constant threat. Until the early fourth century, when to the astonishment of the world the emperor first tolerated what up to then had been an unhealthy cult, and then he, himself, became a Christian, the believer lived under threat.

The Romans held that their state religion, with its organized worship of the gods and, eventually, of a deified emperor, ensured prosperity for Rome. Defeat in battle, famine, plague; for such disasters something must be to blame, and the likely cause was the refusal of the Christians to worship in the state temples. Their weekly gatherings to commemorate the Last Supper were officially described as 'unholy orgies', and when Rome burned down, Nero

had little trouble in shifting blame to the Christians. Not only, were we told, the Christians were too poor to indulge in art, but they would naturally be hesitant to draw any attention to themselves. Erect a statue of Jesus in a courtyard – assuming any Christian had such a luxury – and you were asking to be denounced to the authorities. Matters changed, of course, in the fourth century, but very little art was expected before that.

Imagine the astonishment, therefore, in the 1930s at the archeological discoveries at Dura-Europos. This was a Roman trading post and garrison town in eastern Syria. It stood on a bluff above the Euphrates River, and in the year 256 when, by all accounts the Christians were timorously non-visual, the Persians made a long awaited attack. The town decided to make the houses on its outer rim into an extra wall by filling them with rubble. The Persians did attack and destroyed Dura-Europos, but enough was left of the wall, this constructed wall, for archeologists to discover that on this outer rim had been two places of worship. Both were in houses. One was a synagogue and one a Christian church. The greater surprise was in the synagogue. If historians

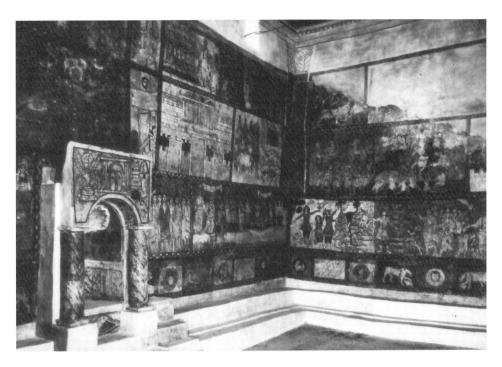

believed that there was very little Christian art before the time of Constantine, they were even more certain that there was never any Jewish art. It was an axiom that the prohibition against graven images bound the Jews either to no art or to purely abstract patterning. Yet, the Jews of Dura-Europos had a synagogue filled with sacred narrative, which discovery alone lead to a considerable revision of the history books. [Above: Synagogue Wall Painting, Dura-Europos.]

The Christian church, also just a few rooms in a house, was considerably smaller and poorer, and less impressive than the synagogue. It is mainly in the baptistry that paintings, though in a ruinous state, can still be seen. [Opposite above: Baptistry Wall Paintings, Dura-Europos, Jesus walking on water.] There are some miracles of Jesus on one wall, and the Good Shepherd in a niche adjacent. [Opposite below: Baptistry Wall Paintings, Dura-Europos, the Good Shepherd.] As you can see, one can hardly call this art. Yet, it is a precious insight into the emotions and desires of these isolated Christians. All who sought baptism stood in this small, poor room where a sadly inadequate artist had tried to express the reality of their Saviour. We may think these paintings to be poor daubs but they expressed a reaching out, an affirmation, a confidence in their religion, which only an accident of archeology (think of Pompeii) has revealed to us. Otherwise, nearly all the third-century art that has survived is hidden underground in the catacombs in Rome.

V

The fields around Rome lie over soft rock, volcanic tufa. It was very easy to tunnel into this rock, sometimes extending for as much as twelve miles underground and in the walls to excavate niches where the dead could be reverently buried. Obviously, these burial places were hidden, and so the early Christians felt free to paint on the plaster that sealed in the bodies. The images that they painted were those that meant most to them. There is both pathos and interest in discovering what these images were. Because the catacombs were forgotten until the seventeenth century, safely concealed, much of the art survives, though some only exists in the watercolours made by the seventeenth-century explorers.

Prominent among these images, as we might expect, and as we saw it at Dura-Europos, is the image of the 'Good Shepherd'. The deacon Callixtus, who was Pope between the years 217–222, is

known to have organized and managed the catacomb that still bears his name. [Previous page: Catacomb of Callixtus, third-century, Rome]. Here there is a beautiful fresco of the Good Shepherd bearing a sheep on His shoulders, holding out His arms to the hopeful sheep around Him, and surrounded by trees and exuberant birds. Jesus had called Himself the Good Shepherd, and had spoken of searching for the lost sheep, yet, for those not in the know, a shepherd was a perfectly acceptable neutral image. Snooping pagans, should any venture into the mysterious windings of the catacombs, would see nothing to alarm them. Numerous as these images are, few of them would qualify as high art, with one major exception.

Somewhere in Asia Minor between 280–290, there was a Christian with sufficient means to commission a genuine sculptor; the statuette that he made of the Good Shepherd has a quiet magnificence. Jesus is youthful, beardless, heroic of bearing, clearly a Saviour. The sheep hangs lovingly around His neck, like a gigantic fur collar, and at His feet, small in proportion to His stature, lie other sheep, happily waiting for their turn to be taken

into the shepherd's arms. What makes this statuette even more interesting is that, when it was discovered in Turkey, four statuettes telling the story of Jonah were discovered in the same hiding place, thus making it clear that the shepherd is not a nature god but Jesus Himself.

Jonah was the second most attractive figure to the early Christians. There are innumerable depictions of him being swallowed by the whale, as in the catacomb of Priscilla, or of him being violently spat forth by the whale, as in the catacomb of Callixtus. But none have the majesty and the extraordinary presence of these Turkish statuettes.

The sea monster seems to have long, animal-like legs, not to mention rakish ears, but his great tail swirls up triumphantly, with nothing left of Jonah but two despondent legs. When this same monstrous creature vomits Jonah forth, the prophet comes out with an air of exultation, arms raised in triumph. We can see how powerfully there is set before us a symbol of the extinction of death and the certainty of Christian resurrection. The third statuette shows Jonah reclining in

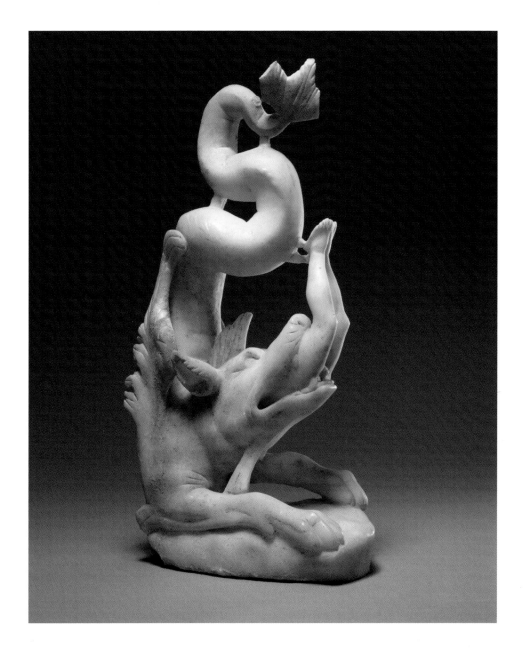

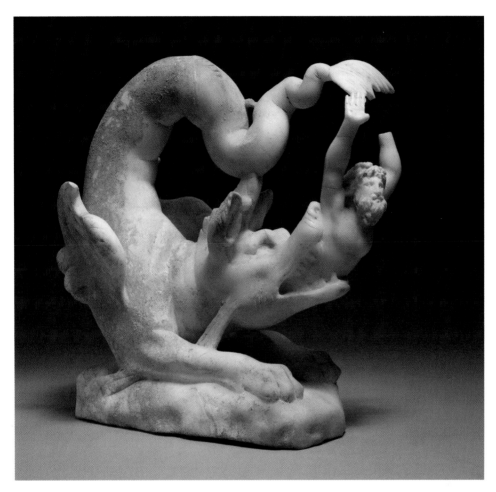

paradise at ease under the gourd tree, all affliction past. The last, which is unusual in the Jonah series – and is my favourite – depicts Jonah with hands held aloft in prayer, looking up to the God who has rescued him. [Left: Statuette of Jonah swallowed

by whale. Above: Statuette of Jonah ejected by whale. Above: Statuette sleeping under gourd tree. Opposite: Statuette standing in prayer.]

Nearly as popular as Jonah was that other escapee from destruction, Noah. In the catacomb of Priscilla he stands in the box that the early Christians considered to be a sufficient indication of the

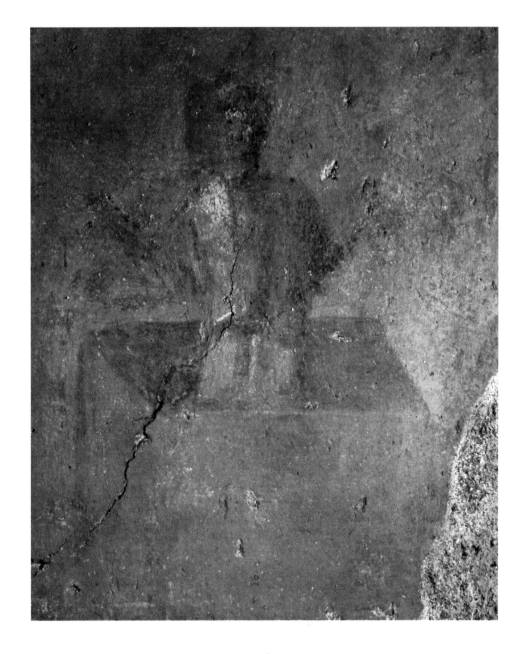

ark. [Opposite: Noah, Catacomb of Priscilla, Rome.] In fact, this confidence that indications were all that was necessary to tell a story are ubiquitous throughout the catacombs. People may not have been able to read or write, but they could listen and ponder.

Clearly these stories, nearly all of which tell of God's miraculous rescue of the faithful, were very well known.

A rare relic of early third-century art that is not painted in the catacombs, is a clay lamp. [Previous page: Lamp with Good Shepherd, Noah's Arc, third-century.] Scholars know the firm that made these lamps because the maker's name, Florent, is stamped underneath. All the other lamps from the Florentius' workshop, show pagan images: gods, animals, erotic drama. But, it would seem, at least one Christian commissioned a Christian lamp, and it shows the three favourite images. In the centre is the Good Shepherd carrying His sheep, with a whole flock gamboling before Him. Right at the top – Florentius could not resist utilizing his normal repertoire – are busts of the sun, the moon and the seven stars, favourite secular images. However, underneath them, to the left of the shepherd is a rectangular box, on which perches a gigantic dove. To the outsider, this would be playful decoration; to the insider, the Christian who would use this lamp, it was a reference to Noah and his sending the dove to discover if the floodwaters had subsided. Underneath the box, so as to waste

no space, is a small Jonah emerging violently from the mouth of the great fish. To the right, the gourd bends over a blissful Jonah sleeping in its shade.

Compared with the statuettes, this is minor art indeed, but one's imagination lingers wistfully on the circumstances of its making. Of course, for all we know, there might have been dozens, hundreds of these lamps. Only this one, though, has survived. Noah, Jonah, the three youths in the fiery furnace, Daniel in the lions' den, Moses leading the Israelites across the Red Sea, or bringing water from the rock, Abraham preparing to sacrifice Isaac until God intervened: the intense desire to be saved, to express their trust in the God who does save, gleams on the walls throughout the catacombs.

VI

It is striking though, how few images there are of Mary. She did not loom large in the faith of the early Christians. She is not completely absent, but it is always in the context of the importance of her Son. There is a very striking image in the catacomb of Priscilla of a mother and child underneath a star to which an impressive male is pointing. Suggestions differ as to the actual meaning of this remarkable scene. [Opposite: Fresco of Mother and child, Catacomb of Priscilla, mid-fourth century, Rome.] Is the man Isaiah, who prophesized that a virgin would conceive, and speaks of the light, 'the glory of the Lord', that would come with His birth? Or could it be the prophet Balaam, who spoke of a star coming forth out of Jacob, which was also taken as a reference to the future birth of Jesus? Another possibility is that this is a truncated version of the adoration of the Magi, which is the scene in which Mary most often appears.

Two Magi, clearly dressed as eastern foreigners, as Persians, approach a seated Mary in the catacomb of Marcellinus and Peter. [Page 32: Fresco of the Adoration of the Magi, Catacomb of Marcellinus and Peter, early fourth-century, Rome.] They bring their offering to the child she holds. When Constantine removed

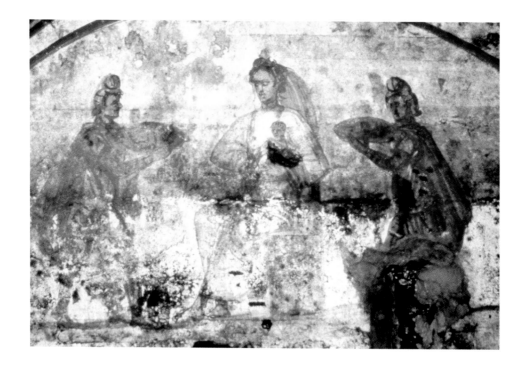

all fear of persecution, and there were wealthier Christians who graduated to stone sarcophagi (sculptured tombs of stone or marble), the adoration of the Magi is often tucked away in a corner. On the lower part of the sarcophagus that is now in France, at Arles, we see the adoration of the Magi: large, vigorous men, holding out their gifts to the child. [Opposite: Adoration of the Magi, marble sarcophagus, mid fourth-century.]

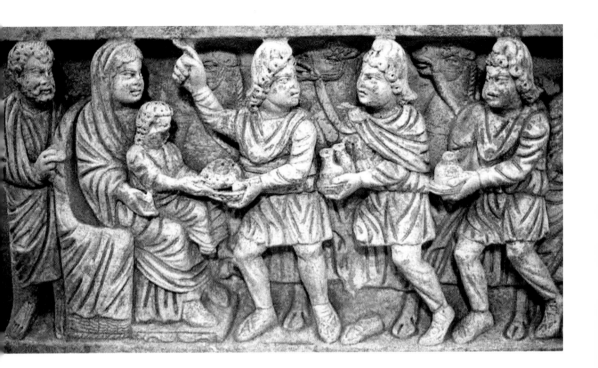

An even more impressive sarcophagus is in Rome. [Page 34: Sarcophagus with dry bones and adoration, early fourth century, Vatican.] This time the left half shows the Old Testament story of the dry bones coming to life, clearly a reference to the resurrection, while on the right, three impressive Magi, with attendant camels and high Phrygian caps, process towards Mary and her child. Interestingly, the leading Magus, who bears the gift of gold, is

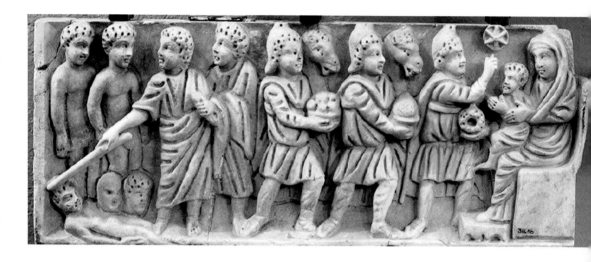

carrying a golden wreath, which was offered only to the emperor. The stress, clearly, is upon Jesus as Lord, upon the world paying Him homage, but apart from the Magi story, there were many other ways to show the Lordship of Christ, and these were usually preferred.

The most famous of all the surviving sarcophagi was crafted in 359, for that rarity, a Christian of high estate. This was Junius Bassus, who was the city prefect of Rome, and who was baptized on his deathbed. [Opposite, top: Sarcophagus of Junius Bassus, upper register; Opposite, below, lower register, Vatican.] His tomb is a most impressive work of art with ten separate

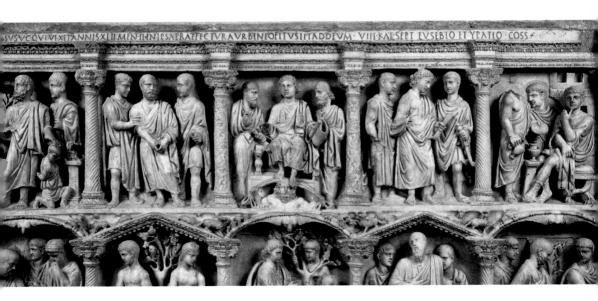

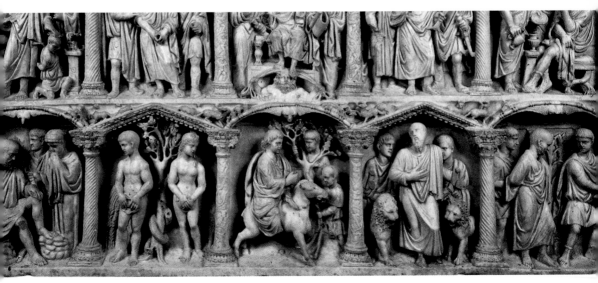

scenes. In the middle, Jesus gives the law to two apostles. On the left, Peter is arrested and Abraham prepares to sacrifice Isaac. On the right, there are two scenes, the arrest of Jesus and His interrogation by a hesitant Pilate. This is the upper register. On the lower, we have in the centre, Jesus riding into Jerusalem to begin his Passion with Adam and Eve to his left and then, an unusual Old Testament image, Job and his false comforters. On the right, we have Daniel in the lions' den and then St Paul being led to his martyrdom. So, of the ten images, the four in the most important positions are of Christ. Two are of Peter and Paul; the other four come from the Old Testament. One might guess that these were the stories that meant most to the noble Junius, '*vir clarissimus*' as the sarcophagus proclaims.

Nowhere has it been felt necessary as a statement of faith to include any reference whatever to the Virgin Mary. This, of course, is fair enough. It is Jesus who matters and Mary's importance is solely in relation to Him. Yet, in the sixth and seventh centuries, this relationship became of intense interest to the

Christian world, and I, for one, was struck by how slowly this interest developed.

VII

We may also be surprised to find no surviving icons from the first six centuries, whether of Jesus or of Mary. Literary references make it clear that icons did exist, painted images on wood which the believer could place in his home or carry with him. Eusebius, who died in 340, tells us that he had examined images of the apostle Peter, 'and indeed Christ Himself'. Epiphanius, bishop of Salamis who died in 403, speaks of painters who 'represent St Paul as an old man with receding hair'. Unfortunately, we know these images only through literature. One might deduce, though, that the interest in St Peter or St Paul was less in what they were like and more in what they represented, the power and holiness of the church. When Epiphanius refers to the Virgin Mary, he describes her with delightful objectivity, as 'a virginal workshop'. Mary was seen as functional, the means whereby Christ became incarnate.

There was great interest in what Jesus Himself looked like, but almost none in the appearance or personality of His mother. The desire to see the face of Christ, impossible though it was, made it almost inevitable that there would be pictorial attempts to capture that appearance.

There are two stories that are particularly long lasting: they still linger on in the Christian imagination. One tells of Abgar, King of Edessa, who was said to have sent an artist to Christ to take His portrait. Jesus refused, but wiped His face with a cloth and gave it to the artist. When Abgar opened it, he found on the cloth a portrait of Christ. This famous image is known as the Mandylion of Christ and represents fully the old idea of 'an icon not made by human hands'. [Page 40: Mandylion from San Silvestro in Capite, sixth century, Rome.] It was an icon to be trusted therefore. No artist had painted it. King Abgar, and all who revered this icon, was certain it was 'correct', 'right', 'orthodox'.

There is a moving account of a pagan woman who mourned that she could not worship Christ if He was not 'visible', if she could not 'know Him'. The writers of the Gospels had no

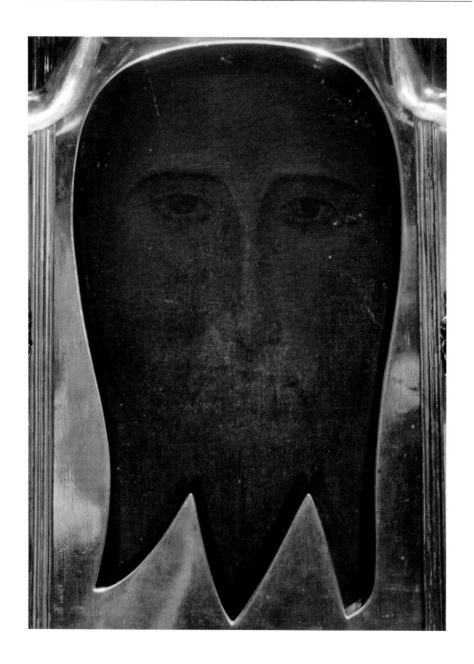

interest whatsoever in the appearance of Jesus, whether he was tall, short, handsome, plain. They were concerned solely not with what he looked like but with what he was, God made Man. It was what Jesus meant that mattered. The early Christians were in agreement with this – their faith was based on what Jesus meant – but they also longed to see Him.

One version of this longing is still current. On the walls of many churches hang the stations of the cross, fourteen separate images before which believers kneel as they follow Christ's journey from his condemnation by Pilate to His being taken down from the Cross. The present Pope has removed from these stations all those which are non-scriptural, but up to now one of the best-loved stations has been that of Veronica, who wipes the face of Jesus. According to the legend, her heart was wrung as she saw Jesus' suffering. She ran forward to wipe His face with her veil and found, afterwards, that the face of Jesus was imprinted on it. [Page 42: St. Veronica's Veil, Master of St. Veronica.]

Veronica's name means 'true icon', 'vera icon', which hints of the symbolic nature of the story. This veil is even more famous

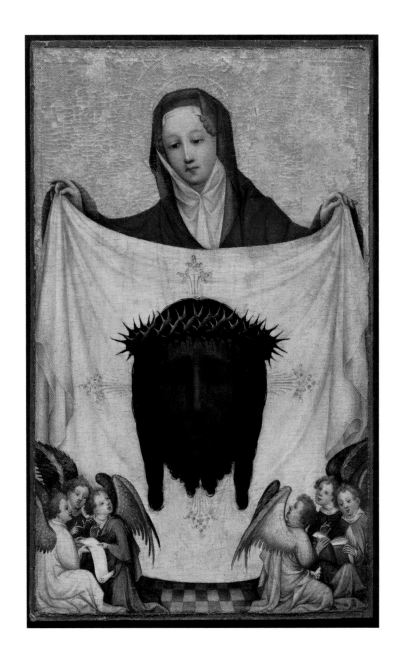

than Abgar's Mandylion, a copy of which hangs in the Vatican. That there is no literal truth in either story does not obscure the human longing actually to see – to know – what Christ looked like. This longing seems to have been there from the early days, but it was not until the sixth century that we see evidence of the same longing to see Mary and understand her personality. This is explored to extraordinary effect in the eight surviving seventh-century icons of the Virgin, the ancient icons, which are wholly unique.

VIII

Professional archaeologists sometimes come to a completely barren layer. Either there was a fire and so there is no trace of the buildings that once occupied the site or, for some reason or another, there was an exodus, and the soil is bare of all archaeological remains. Something like this happens in iconographical history. In 726, the emperor Leo III issued an edict against all visual images of the faith. The icon of Christ that dominated the palace gate was destroyed and there began a systematic attack on the use and veneration of icons which until then had distinguished the Byzantine Empire.

Iconoclasm, of course, is not a unique phenomenon. We have known it in our own culture, when the sixteenth and seventeenth-century Puritans destroyed much of our medieval visual heritage. We find the same on the continent when fanatical followers of Zwingli and Calvin rampaged through the churches of

Switzerland and the Low Countries, and again, at the time of the French Revolution, when much of the great Gothic art of France was defaced and obliterated. Much of this destruction was motivated by pure intentions. The iconoclast felt that the worship of God was diminished by the use of images.

Whether this was true in the eighth century in the Byzantine Empire is arguable. Historians suggest there were political reasons, such as a desire to undermine the power of the Orthodox Church, or even military reasons. Muslim armies were defeating the forces of Christianity, and might that be because they renounced the image which the Christians embraced? The Byzantines had proudly fought under the protection of their great icons. What then did defeat imply? For whatever reason, the emperor entered into a life-and-death struggle with those who honoured the icon, iconophiles (the icon lovers). His son, Constantine V, 741–75, intensified the struggle. The destruction of all icons veered between absolute and relative until the middle of the ninth century. In 842, Theodora, widow of the previous emperor, became regent for her son Michael III, and to her fell the

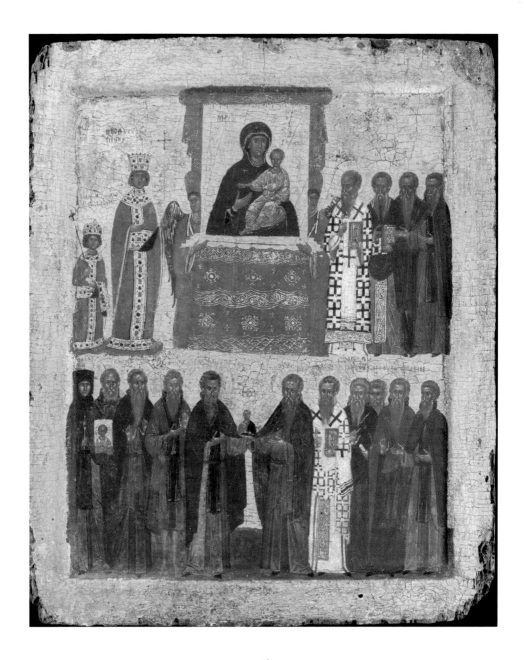

honour of reinstating the importance to the Orthodox Faith, of icons. Ever since then, the Sunday when the icon came back to the church has been celebrated as a major feast, the Feast of Orthodoxy. [Opposite: Icon of Triumph of Orthodoxy, fourteenth century.]

After this date, we find icons as we know them today. They are integral to the Orthodox liturgy. It has been well said that whereas for Catholics there is a written theology, for the Orthodox, theology is visual. It has become an integral part of their liturgical worship, and even the most private of icons shares in this profound, sacred significance. The Church took control of icons. It laid down rules for what was to be painted and with what dispositions it was to be painted. The icon painter fasted and prayed, he was a recognized part of the ecclesiastical order. Since he was making visual the mysteries of theology, he was not so much a painter as a writer, and the Orthodox description of the creation of an icon prescribed the 'writing' of it rather than of the 'painting'. We 'read' an icon.

I X

But all these prescriptions and significances apply to post–842. Between the seventh and ninth centuries, a great gap is set from which no icon survives.

What concerns us here is the semi-miraculous survival of eight icons of the Virgin that would have been destroyed with countless others had they been found in the strict confines of the Byzantine Empire. As it happens, five were in Rome, over which the emperor had no control, and two were in the remote desert Monastery of St Catherine at Mt Sinai. Justinian had built this monastery in the sixth century, but one hundred years later it had escaped Byzantine control and owed its allegiance to Jerusalem.

These seven icons, from the sixth or seventh century, together with an eighth, which was discovered very recently, have little in common with the Byzantine icon as we know it, except for their shared reverence for the Mother of God. They are icons of

such overwhelming power and freshness, and of such beauty and holiness, that to encounter them is to encounter a numinous reality which I have found nowhere else.

In each case, the quality of the painting (or, if you like, the writing) suggests that they were created by some artist in Byzantium, which became Constantinople and is now, of course, Istanbul. But, in fact, we know nothing of the origin of these icons, despite the legends that have accrued to several of them; two at least are said to be not made with human hands! There are differences in shape and in size, but they are alike in their insight into the reality of Mary as a woman and as the privileged Mother of God. They are all extraordinary.

X

Inevitably, the traditional icon has been a problem for the art historian. Here are works alive with the most splendid colour (Matisse confessed he was bowled over when he went to Russia and saw the icons face to face), and with an emotional power equal to that of any Renaissance 'Old Master'. Yet, the aesthetic effect is a matter of indifference to the iconographer. The icon may be beautiful, but that is because it is an image of a spiritual beauty, of Christ or His Mother or the saints.

When St Paul wrote to the Colossians, a few years after the death of Christ, he described Jesus as 'the icon of the invisible God'. Icon means image, it is the true picture. The iconographer and those who prayed before the icons believed that they were entering into that spiritual world where God is supreme. This is something completely different from the religious art of the West. Fra Angelico or Raphael, for example, are bringing the sacred into

our world. The western artist is domesticating the sacred, making it intelligible to us. The Byzantine artist, however, is taking us from our world into the world of the sacred. Mary and Jesus are not domesticated. They are drawing us out of our worldly reality into their world, the true world, summoning us to leave behind all that is earthly and to breathe an air more pure than we can understand. Icons are for prayer. They are painted in prayer and their intention is to take us into a state of prayer. Some Orthodox theologians would claim that one who does not believe cannot truly see an icon. It reveals its meaning in proportion to the purity of our faith.

Ah, the poor art historian! How is he or she to deal with this? Always we are straddling a difficult line, between our response to the image as a thing of beauty and our response to the image as a means of communion with God. I cannot attempt to resolve this dilemma. I can only say that even non-believers who open themselves to the power of these icons cannot but encounter the ineffable.

XI

Although I would not presume to call myself an art historian, I must confess to having shared in the art historical wariness of the icon. When I hear that the director of one museum has written to the director of another, asking advice 'on the icon problem', my heart sinks but I know what this scholar means. Until I realized that I would never experience the true beauty of the icon, unless I regarded each icon as a means of entering more deeply into the experience of God, and that I should forget all about trying to integrate them into a history of art, I was somewhat, and foolishly, at a loss.

What liberated me from my near-sighted folly was the icon I saw at the Temple Gallery in London in the summer of 2003. Up to then, books on Byzantine art or on icons in general had lamented that only seven icons of the Virgin had survived the period of Iconoclasm. All seven were known, though by no means

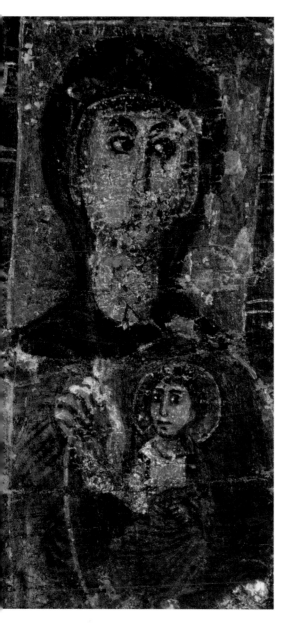

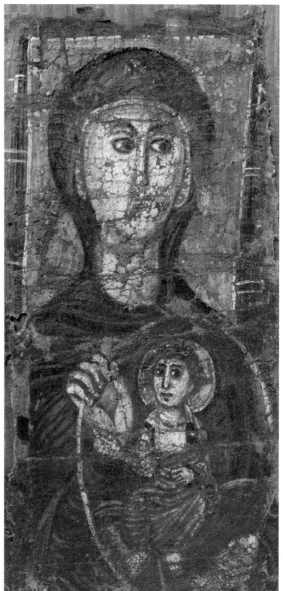

well known. What happened in 2003, however, meant that the history books had to be rewritten.

Dick Temple and Laurence Morrocco, discovered in a small auction house in Avignon, France, a blackened and tattered encaustic image, which, they could recognize, was a very early icon of the Mother of God. [Page 53: Icon of Virgin and Child (before cleaning, left); Page 53, (after cleaning, right), Egypt sixth or seventh century, Temple Gallery, London.] The use of wax, which is what encaustic means, is limited to the early centuries, but it was the sheer power of the image itself that convinced Temple that he had found something of extraordinary significance. It is a painting on linen, and when it was discovered it was clumsily glued onto a rectangular piece of cardboard. It took the Temple Gallery two years to clean it and to consolidate it, two years also in which they sought to find its origin. The general consensus seems to be that it hung in some church in Egypt during the sixth or seventh century and has miraculously survived to give us an unimaginably precious insight into the poetry of early Christian thinking.

XII

The Virgin herself, with her oval face and swanlike neck, looks away from the viewer. Apart from a gold cross over her forehead, she is simply dressed in black and shades of brown. Opinions differ as to whether she has behind her a square halo, or whether the coloured rectangle, with its white attachments, is merely a support for her head. Later Christian art uses a square halo to indicate that the saint is still alive. This does not seem to be a sixth-century custom; there is a box from an Egyptian tomb painted in the sixth century, which also uses the square halo and it is clearly depicting a saint. Whether halo or backdrop, this colourful square draws attention to the Virgin's beauty, and also makes it impossible to ignore her desire to withdraw from our gaze, so that all our attention may be directed to her child. Her gentle removal of herself from our attention has been described as aloof, but it does not seem so to me. She is well aware of our presence, and by

no means indifferent to it, but all that matters to her is that we should regard the little Jesus. The passion that is absent from her face is visible in the very firm grip with which she holds the mandorla.

A mandorla is almond shaped, rather like a shield, and we find it surrounding the infant Jesus on many early icons. It has been wondered if there is a reference here to the shield on which the Roman emperor was accustomed to display his son to the waiting army. For the Christian, the son of the Roman emperor, his heir, has given place to the child Jesus, equally emperor, but in no worldly sense. Usually, this mandorla or shield is coloured.

There is a striking seventh-century Virgin at the Monastery of St Catherine at Mt Sinai, which is so destroyed that it does not count among the surviving eight. We can still make out, though, that the Virgin holds her Son enclosed in an oval shield that is bright red. Here, however, the shield or mandorla, is transparent. We can see Mary's large and powerful hand grasping the rim, as she subdues herself completely to the reality of Jesus. Further-more, as it is transparent, we can see through to the place of Mary's

womb. This is her significance: that in her, God, the Word, became flesh. Above her head does not run the inscription, 'Mother of God', but of, 'Holy Mary', another pointer to the earliness of the icon. Only after Iconoclasm, did 'Mother of God' become the regular title for Mary. Here, her motherhood is implied by her actions.

XIII

Wonderful though I find this Madonna, what seems to be truly extraordinary is the depiction of the small Jesus. I have never myself shared the desire of the early Christians to 'see the face of Jesus'. I know him in a different way. But, as anyone who loves art must know, there are countless beautiful images of the Lord right up to modern times (think of religious artists of today like Craigie Aitchinson or Albert Herbert, or of yesterday, like Stanley Spencer). However the artist has depicted Christ, whether in power, Lord of All, or in pain, vulnerable to human cruelty, Jesus is always shown as resolute. This is the Christ: He who knows the answers. After all, Jesus is the answer, whereas we, in fact, hardly even know the question.

This small Egyptian Jesus, or he may be Palestinian or Syrian, looks out at us without this inner certainty. This is a child, an anxious child. He knows that there is an answer, but yet not what

it is, and His big searching eyes implore us to join with Him in His quest. He is small, but not a baby. He has a rough mop of red curls, dark eyes, and a strong masculine mouth. Here we can see a likeness to His mother: whose rosy lips are womanly, but very firm. In one hand He holds what may be a scroll, but we feel that perhaps He is independent of written wisdom. This is a child alive with a passionate desire to seek the Truth and pleading with us to join with Him in this all absorbing search. His small, sandalled feet dangle in human vulnerability as He shows Himself to us, held and yet not held, by His mother. She holds the mandorla, not the child. He is there for our possessing, human, unprotected and haunting, an image like no other.

Once I had seen this icon, all my nervous reserve disappeared, and I realized, with amazement and joy, that these early icons of Mary had a spiritual power that I had never seen equaled. Gazing at this icon in the Temple Gallery, and at home, living before a full-scale replica, made me desire to see the other seven Virgins.

Travel is not easy for me, and deeply antipathetic, but the pilgrimages I then made have been infinitely rewarding. This is

what I am trying to share with you, and the impetus to travel, and to contemplate, and to share, all came from this, the last of the Virgins to have revealed herself.

But who knows? This Virgin came out of nowhere, so to speak. What might still be hidden in attics and cellars, in cupboards and boxes, in the store rooms of remote museums?

XIV

The first stage of what I came to consider a pilgrimage, took me to Rome. Here, by the grace of God, five icons have survived the fury of Iconoclasm, and I did not anticipate much difficulty in finding them. Quite apart from their intrinsic significance, I knew there had been two recent exhibitions in Rome, devoted entirely to these rare survivals of our early Christian past. The first exhibition was in 1988 and was held in the apse of the Basilica of Santa Maria Maggiore. The five images for the first time came together so that the world could experience them. Reports say that people in general were rather baffled: there was scholarly curiosity, but also a feeling that a merely intellectual response fell short. These icons held so much of the Christian longing to understand the mysteries of God, that an intellectual appreciation, mainly of their antiquity, struck some people as almost vulgar.

In the year 2000, three of the images met again for an exhibition focusing on '*Aurea Roma*', 'Golden Rome', showing how the city moved from its pagan past to its Christian future. What made this exhibition special was that one of the two of the early Sinai Virgins, the one that is in Kiev, came from the Ukraine to join the Roman icons and extend our understanding of what such an encounter could offer.

Knowing this, I launched myself into Rome with happy confidence. Two recent exhibitions: my Roman friends would surely have seen them and could direct me to the icons. Disillusionment was ahead. Somehow, exhibitions do not linger in the memory, or maybe it was only because Rome is of an exceptional cultural richness and its lucky citizens have almost too many opportunities to experience the glories of the past. Only two icons were fully visible. One could be found if I knew how to set about it; the whereabouts of the other two seemed to have been completely forgotten.

XV

I began with the most resplendently housed of all the icons. It is enthroned in the Basilica of Santa Maria Maggiore, as it has been for centuries. This is one of the grandest churches of Rome, and one of the earliest. It was built in the fifth century by Pope Sixtus III (432–40). The Council of Ephesus, 431, defined the significance of Mary as Mother of Christ. The proclamation gave rise to an immense surge of interest in this young and obscure Jewish woman, called to such terrifying responsibilities. This was the first Roman church dedicated to her, and the suggestion is that it was not long before the church celebrated the dedication by acquiring the treasure of a Byzantine icon.

The ancient tradition, of course, claims that the icon was painted by St Luke, but if not exactly from the first century, it is certainly one of the earliest survivors. Over the centuries, it has been over painted in parts, and it is still the only icon that has

never been restored. Gerard Wolf, the Byzantine scholar, calls it 'a kind of palimpsest icon, which was restored from time to time in different areas'. But essentially, he thinks it is not only an early icon, but might even date from the consecration of the Basilica by Sixtus III. So revered was it, that right until the seventeenth century, there was a yearly procession on the feast of Our Lady's Assumption, August 15th, which the Orthodox Church knows as the Dormition. This procession brought from the Vatican the mandylion which was considered an image 'not made by human hands'. This ceremony expressed a faith, that we might find rather childlike, but which rested upon a conviction that both icons revealed a truth beyond human fashioning. In this large and magnificent church, the little icon, at first, is almost invisible. Only after moving around the great building, dazed with splendour, did I finally come to the Pauline Chapel which was completed in 1611. [Opposite: The interior of the Pauline Chapel, Basilica Santa Maria Maggiore, Rome.]

It is impossible to describe the glories of this chapel, where coloured marbles, golden angels, elaborate decorations, immense

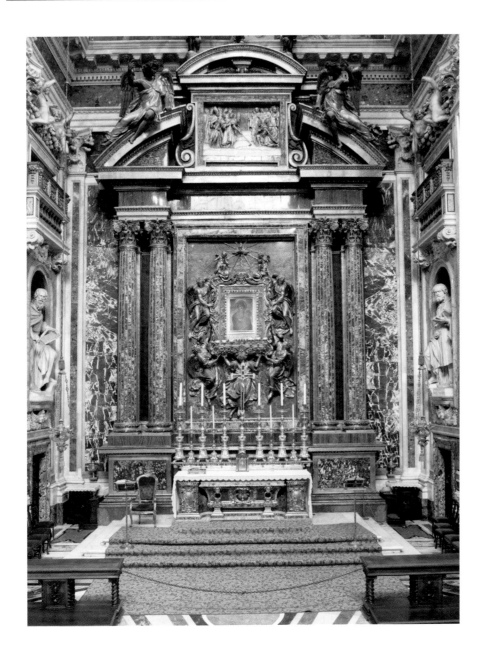

sculptural memorials, combine to give an impression of dazzling grandeur. The space is filled with light. In the centre, above an altar gleaming with marble extravagance, hangs the ancient icon. The last and supreme work of the sculptor, Camillo Mariani, was to create around the image a 'glory'. This 'glory' is made up of exquisite golden angels that seem to hold up the icon, and glow from within in response to it. The icon, it would seem to me, needs no external glow. [Opposite: Icon of Virgin and Child, Santa Maria Maggiore, Rome.]

Small and simple, it almost disappears in the visual alleluias in which it is embedded. This Mary has a long, intelligent face, and she looks rather quizzically across at the devotional stridence of her setting. She holds her Son with crossed hands, unafraid but wary. The little Jesus has a head of dark curls, holds a brightly decorated book (surely the Gospels?) and reaches out His hand in blessing, not to us, but to the world that He can see and Mary cannot. For all its simplicity, this is a sophisticated and tranquil image. Mary and Jesus are content to be the centre of an extravaganza, if that is to the benefit of the faithful.

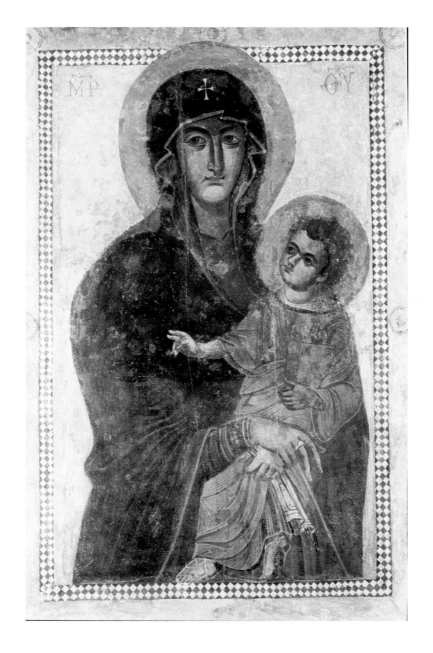

This image has a beautiful name: '*Salus Populi Romani*'. The usual translation is, 'the salvation of the people of Rome' but '*salus*' can also be translated as 'health'. I like to think that it is healthy for so rich a church to be reminded of the poverty and innocence of the human Jesus. The Pauline Chapel is intended as a sincere expression of devotion, but Jesus and His mother lived, and would have chosen to have lived, in a way very alien from such baroque grandeur.

XVI

Interestingly, this ancient church is still adorned with some of its sixth-century mosaics. The huge nave, with its porphyry and serpentine pavement, ends in a wide triumphal arch, and on this arch are ancient mosaics describing the infancy of Christ. The mosaics seem to me earlier than the icon, because Mary is still seen as mainly functional, whereas in the icon it is a living woman who looks out at us. She is dressed as an empress in both the Annunciation, where there is almost equal attention paid to a bewildered Joseph, [Page 70, top, Annunciation; Page 70, below, Magi of Santa Maria Maggiore, Rome], and in the encounter with the Magi. This last image is unique in that Jesus is not seated on His mother's lap. The artist has set Him on a wide throne, with Mary to the left, and, to the right, a woman in sobre attire. I would read these as the two women who have appeared throughout medieval art: Mary, in her glory, representing the church, and Eve,

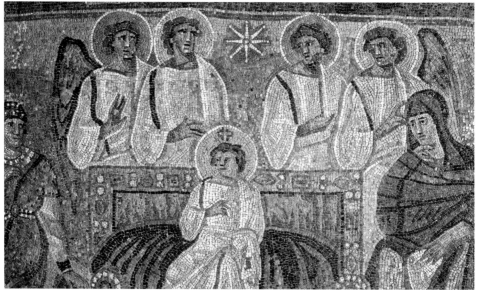

sad and cloaked, representing the synagogue. In other words, despite the exuberant presence of the Magi, the star, St Joseph and the angels, the impressive Jerusalem looming in the background, this is a symbolic picture, and Mary is not here as herself.

Perhaps, I should add, I see a difference between frescos and mosaics that are on walls, always there, images for all to see, and an icon which is essentially private and moveable. It may be used in a fixed position and in a church, but it has risen from private devotion, and has a personal connection with us that gives it its power.

XVII

The second icon that is always on display, and like *Salus Populi Romani*, is one of the treasures of Rome, is also in a great church, that of Santa Maria in Trastevere. This icon, too, has its own chapel, to the left of the main altar, and it is a far larger and more visible image than the shy little Virgin of Santa Maria Maggiore. In fact, it is an exceptionally large icon and was clearly painted by somebody who knew well the imperial court in Byzantium. [Opposite: Icon of Santa Maria in Trastevere, Rome.]

The tentative date is at the very beginning of the eighth century, and it has the beautiful title of *Madonna della Clemenza*. This translates as 'clemency', which is not a word we use very often. The suggestions are of pity, compassion, mercy. This is the Madonna who cares for her children. Yet, of all the icons, this is the most hieratic. She is dressed in full imperial regalia. She wears a crown dripping with diamonds or pearls, and she is seated on a throne,

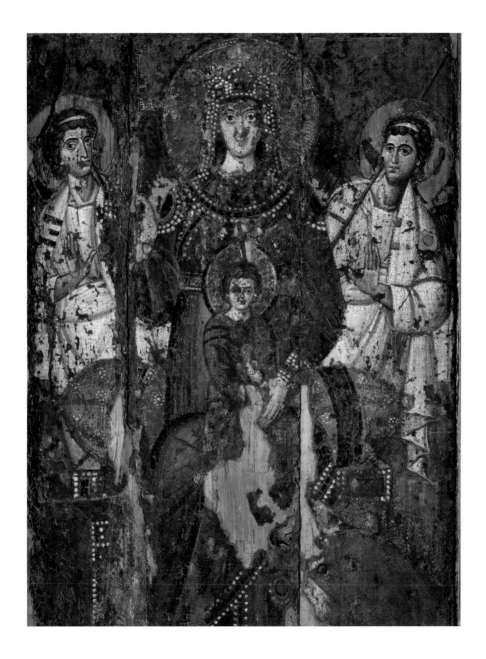

an enormous scarlet bolster. In one hand, though this is not always easy to see, she holds a metal cross, which was not painted on the encaustic that is found on the rest of the icon. It was painted in later to replace a metal cross, a relic of the times when it was customary to adorn icons with expensive gifts. Mary looks straight ahead at us with an almost deadpan expression: this is the Queen of Heaven on display.

The little Jesus, whom she holds on her knee, has a sweetness of expression, rather lacking in His majestic mother. Yet, the affection with which she clasps Him makes it clear that they think as one, and that as she grants us an audience, it is only for the purpose of extending to us the clemency which is the prerogative of Jesus. Since she is shown to us as Queen, it is only right that her elaborate throne, richly studded with jewels, should be flanked by attendants. On either side of her hover two beautiful angels. When I first saw the icon, I took it that the outspread hand, which each holds out to us, was warning us to keep our distance. This is an Audience, with a capital 'A'. We must approach Jesus and His mother with complete seriousness. We

must know what we are doing. We must come slowly and with reverence.

But, I think I misread this gesture, or rather, though it may be indeed a kindly warning, it is primarily something else. I say this because there is an inscription on the frame, partly destroyed, but still readable. It is in two parts and the first refers exclusively to the archangels: '*astant stypentes angelorum principes gestare natym … a*'; 'the archangels, the leaders of the angels, stand in awe at the birth of Jesus'. A second line of this inscription has also survived, which speaks of the divinity as being made by itself, '*ds*' (a shortened form of *Deus*) '*qyod ipse factys est*'. Obviously, the first part of the inscription is inviting us to share in the wonder of the angels at the human birth of the Son of God. The second part might be more subtle. It refers to the fact that Mary is merely the vehicle in which God Himself made Himself incarnate (that 'virginal workshop'), but there may also be an intention to refer to an icon 'not made by human hands'. It has made itself.

XVIII

With its unusual size and powerful colours, this is a very impressive icon. There is a significant difference between the human figures, so still and stately, and the greater warmth and animation of the two attendant angels in 'their stupefaction'. Those who have looked long and lovingly and prayerfully at this icon claim that one of the angels has a Grecian cast to his face and the other is a true born Roman. I admit the subtleties of this escape me, but I am prepared to accept the impressions of those who have the privilege of knowing the image far better than I.

On my visit to the church, I found the chapel a hive of activity since the icon was being removed for its annual procession around the parish. I was lucky. This gave me a chance to encounter it more intimately. It was only when I was closer to the image than I had dared to expect, that I realized that there was a fifth figure in the picture. [Opposite: detail of the Pope at

prayer from the Icon of Santa Maria in Trastevere, Rome.]

At the foot of the Madonna on her throne, fragmentary and hard to read, is a depiction of a Pope at prayer. His humble, trustful posture spells out to us our need of God and the confidence

we should have in the Divine Mercy. It was Pope John VII who commissioned this icon, as well as the mosaics in the chapel of the Virgin, which he had built in old St Peters. Those mosaics have long disappeared, along with the church, but we know that the Virgin there wore the same rich, purple garment and the same crown. In the mosaic, he kisses the Virgin's feet. It was Pope John VII who called himself, 'servant of Christ', and in this icon it is that attitude of obedience and submission that we see in his body language.

This is the only historical figure in any of the icons and it adds a new dimension. If the angels speak of eternity, and the contemporary figure of the Bishop of Rome speaks of the actual present, then Mary and Jesus speak of time transformed, time that is potentially eternity, because the Incarnation gives it a new significance. The angels float, Mary and Jesus stand on our earth, while the Pope is a portrait of a living man striving to enter into blessedness. We will see these attendant angels again and again in icons, but never more freshly and surprisingly than here.

XIX

According to the guidebooks, although they do not seem to rec-
ognize its importance, the third ancient icon of the Virgin is in the
Pantheon. What distinguishes this church, the proper name of
which is Santa Maria ad Martyres, is that of all ancient Roman
monuments, this is the most impressive and the best preserved.
[Page 80: The Pantheon, Rome.] The Colosseum is a ruin in com-
parison. It was built by Agrippa in 27 BCE, and it is the only great
Roman monument that was given to the church.

When Pope St Gregory the Great sent St Augustine to convert
the English, he pressed upon him not to destroy pagan temples,
but to reconsecrate them to Christ. The supreme example of this
happening in Rome is the consecration of the Pantheon. The
emperor Phokas handed it over to Pope Boniface IV in 609. This
was an extraordinary gift, because the Pantheon was a sublime
example of the Roman genius for architectural engineering. Up

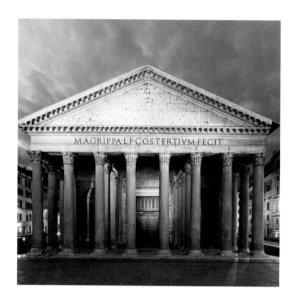

until almost yesterday, the nineteenth century, it remained the largest, unsupported rotunda in the world. It was the discovery of cement and its tensile power that made such an achievement possible, but in its pagan heyday the cement was hidden beneath a splendid cladding of marble. The Christian church has been stripped of much of this magnificence, though it remains open to the sky and is a space seemingly receptive of all spiritual possibilities. When Pope Boniface consecrated it as a Christian church, he is said to have replaced the pagan 'idols' with barrows full of relics

from the catacombs. Although that may be partly legendary, it is certain that he enshrined in the church a very early icon of the Virgin. I was eager to see her.

The Pantheon is a very large church with very high walls, curving though they do. It took me several concentrated circuits to discover that on no wall could I see an ancient icon. Distress! Anxiety! Appeals to whomever seemed to have some ecclesiastical authority in the building! In a stuttering mangling of Italian and Latin, I finally received the message that I must approach 'the architect'. In itself, this was a dead end, but I was blessed, immeasurably blessed, in having a good friend who had worked at the Vatican Communications Department and to whom all Rome seemed to be an open book. She finally discovered that the icon is not on display but is actually underneath the Pantheon, in what is known as the Chapel of the Canons. It is part of the sacristy because, despite its flooding tourists, the Pantheon is a working church.

There was a certain thrill in going down the uneven passages beneath the church and winding our way down a narrow

corridor to where the priest vests for Mass. At its far end was an altar, and above it, a small icon. [Opposite: Icon of Santa Maria ad Martyres, Rome.]

Although scholars date it to 609, it is not painted with wax – encaustic – like most of the early icons. It is a tempera painting rather like early medieval works, and this technique does not allow for the subtle graduations that one finds in an encaustic icon. It is marvellous all the same, a work of supreme grace, both monumental and intimate. The icon is not in good condition and the half-length figure of Mary has been cut out from a larger work and ends abruptly. She looks out at us with a dreamy dignity, lost in a world of intimacy with her God. She holds her child and also points to Him, her hands seeming to do both at the same time. The little Jesus is alive and active, challenging us with eyes, like His mother's, fixed on something within. They stand there underground, with the weight of Rome pressing upon them, content to be unseen and unrecognized, but alert to all our spiritual concerns. It seemed to me a deeply contemplative image, as if merely to be within its orbit, was to be blessed.

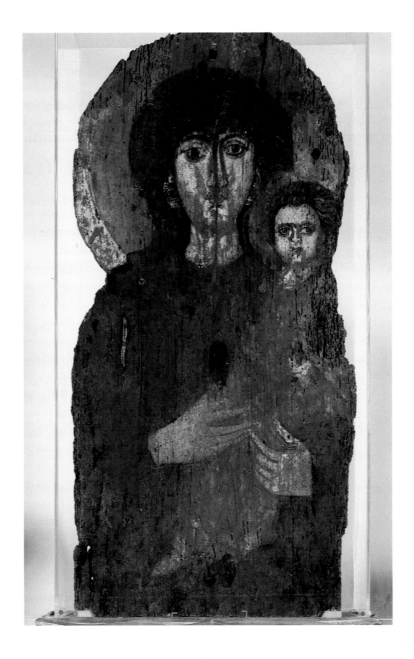

It was the custom in Rome to gild the hands of a healing image: Aesclepius, the god of healing, was always shown with golden hands. We may have to look carefully, but we can still pick up the gleam of gold on the hands of this icon. [Opposite: detail of the hands.] It is a precious memory of graces received through prayer in its presence. Kneeling there in silence, in the low Chapel of the Canons, alone with the Virgin and Child, with tourists thundering overhead, I could grasp something of the awe-filled reverence with which this icon has been approached over the centuries. Am I sorry it is not on display? Yes, and no. I would love for all to see it because it seems to me imbued with grace, and yet there is something appropriate in going down into the earth and approaching the Virgin in semi-darkness and in solitude. It may be selfish, but I would not have wished it different.

XX

The remaining two icons were certainly known to exist, because they had been in both the 1988 and 2000 exhibitions. Yet, nobody seemed to know where they were. Even my omniscient Vatican friend confessed herself at a loss. However, as I had always hoped, she eventually discovered the whereabouts of both (there was an almost thrilling element here of a detective story), as clues were pursued, red herrings sniffed and dead ends blocked up.

Easier to find was the Virgin of Santa Maria Nova, a misleading title. This icon was almost certainly in the church of Santa Maria Antiqua and, at the end of the seventh century, we are told that Pope Sergius I (687–701) had a silver coating made to cover all the icon except the faces of Mary and Jesus. But Santa Maria Antiqua collapsed in an earthquake and the icon moved to its 'descendent', Santa Maria Nova. Now it is in yet another church, Santa Francesca Romana, or rather, it is in the care of

the monks of the very small Benedictine monastery, which adjoins this church.

This is an out of the way church, overlooking the Roman Forum. To get there, one moves off the city street and up a semi-cobbled path, between trees and flowers and singing birds. One could feel one was in the country, not in the heart of a great city. The monastery has a very small chapel, the technical name of which is their 'choir', because the monks meet there during the day to sing the Divine Office in praise of God. In this very simple room, on a simple wooden altar, stood the icon that is the most miraculous survivor of the eight.

It originally seemed to be a nineteenth-century religious painting of rather poor quality. The restorers felt certain there was something underneath, and sure enough, they came across a sixteenth-century painting of the Madonna and Child. This was of poor quality too, but underneath could be glimpsed the heads of Jesus and Mary, of a thirteenth-century painting. This, also, was not very wonderful, though infinitesimally more appealing. To their consternation, the restorers could now see that underneath this

layer were fragments of a wax painting, that encaustic technique which always indicates a work from the time of early Christianity. They bravely took the plunge, and discovered two fragments of encaustic panel, cut down from what must have been a very large icon indeed. Only the sacred heads had been preserved. What was revealed, of course, is the icon at which you are now looking, perhaps the most exquisite of all images ever painted of Mary. [Opposite: Icon of Santa Maria Nova, Santa Francesca Romana, Rome.]

Scholars believe that her head has been stuck on at a slightly incorrect angle, and that when Pope Sergius I originally covered the icon with silver, all those centuries ago, Mary was gently inclining toward her Child. The little Jesus is almost unreadable in the present state of mutilation. We can just make out resolute features, and a hand raised to bless not us, the onlookers, or the world beyond, but to bless His Mother. Although only a head of the Christ Child survives, it is an impressive head, responding with love to the woman who gave Him birth. I must confess, that in this icon, this miraculously preserved icon, one has eyes only for

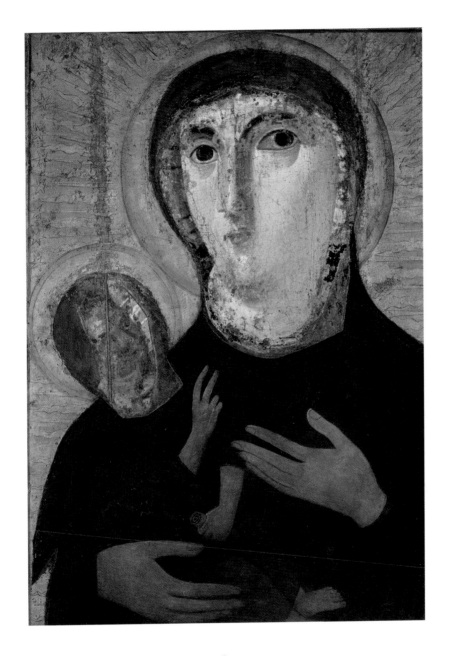

the Virgin. The sweet pallor of her complexion, with the delicacy of its flushed cheek bones, the large compelling eyes, the small bright, resolute mouth: all somehow add up to a portrait of exceptional beauty and intimacy. The Virgin seems lost in the bliss of her being. She lives in a state of tranquil joy that is unique and comes solely from her closeness to her God. This is an icon almost impossible to describe. It leaves me breathless with wonder.

I remember filming a broken Egyptian masterpiece at the Metropolitan in New York, a sculpture of the most refined perfection, and thinking, rather sadly, that ours is an age that feels uncomfortable with perfection. We like the authenticity of the broken and vulnerable. So it could be that the great misfortunes that have befallen this icon, culminating in its almost destruction, with only two large heads intact, enable us to respond at a greater depth than if it had come down to us in its perfection. If one could encounter only one of the five Roman icons, I would choose the Virgin of Santa Francesca Romana.

XXI

Or, would it be the Virgin of San Sisto? This, the last of the Virgins in Rome, the most difficult to track down, was also a dazzling revelation. She was essentially rediscovered in the 1960s and there are certainly art historians who consider her 'perhaps the most beautiful icon of the Virgin in Rome'.

This icon has a legendary history and there is a delightful story that, at the time of iconoclasm, the patriarch of Constantinople, Germanus, saw her escape to Rome, standing upright on the waters and covering the distance in a day. In other words, there is no historical evidence of where this icon came from or to what church in Rome it belonged. Strangely, it always seems to have been protected by nuns. Another legend, equally dramatic, holds that the Pope tried to take it from its small Benedictine convent and install it in the Vatican. However, every night it flew back to the nuns, and when, in the thirteenth century, the nuns became

Dominicans, and moved, the icon moved with them. The nuns moved again and, yet again, the icon stayed faithful.

Since the 1930s it has been enclosed in a Dominican convent on Monte Mario, on the outskirts of Rome. This is an enclosed convent and we made the long journey out into the country to see it. When one comes into the small chapel, there is nothing visible because the icon is on a turntable facing into the sisters' choir, so that they have the blessing of her presence all the time. We attended Mass there, with the community invisible, since they are strictly enclosed, and only the sweetness of their singing reminded us of their presence.

After Mass, the great moment: the swivel slowly turned and the Madonna of San Sisto (also confusingly called, Santa Maria del Rosario) swung into view. I had waited long for this, and to my distress, I found my gaze riveted by the Virgin's hands. Over them had been pasted large and hideous golden gloves, pitifully out of keeping with the extraordinary reality of the Virgin herself. As a nun myself, I immediately blamed the nuns. They wanted to do her honour, I thought despairingly, and the dear

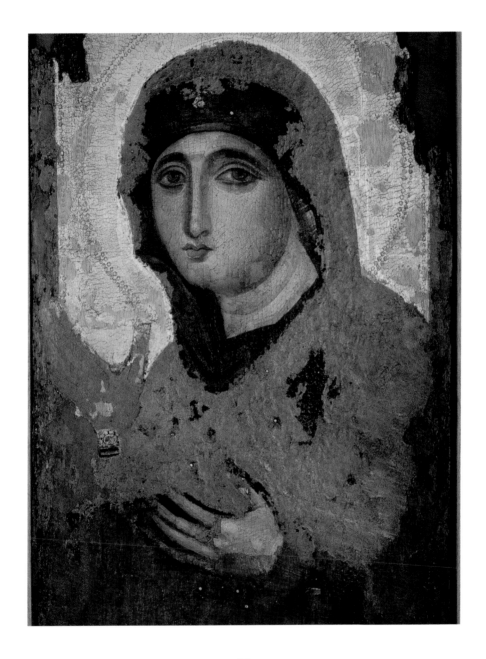

sisters had not realized how inappropriate was their well-meaning tribute.

I take it all back, I now understand that the golden gloves come from antiquity and are the traditional method of proclaiming that this is an icon that works miracles. The gloves are the equivalent of the gilded hands of the icon in the Pantheon. But, once I had got over the gloves, I could see the wonder of this icon. [Previous page: Icon of San Sisto, Rome.]

It is the only one in which Mary is not holding her child. In all the others, the relationship with Jesus is spelled out: His mother holds Him to her heart. We are honouring Mary in her privilege, in her sanctified condition as Mother of God. But this small icon has empty hands. They are raised in prayer like the orans figures of the catacombs, and Mary is like us, she is united to God because, without visible contact, she believes in Him.

The icon that is honoured in this contemplative convent shows us a beautiful, human woman, bright cheeked, red lipped, large eyed, but the gold background tells us that she unites her humanity to the holiness of the Godhead. Those empty hands

(remove the gloves) and that look of indescribable peace, of an inner and transforming certainty, speak very powerfully to our own condition. The unknown artist in the sixth, seventh or eighth century, who sought into his Christian heart to discover and make visible an image of Mary, was inspired by a sense of the faith that draws us as strongly today. After Iconoclasm, no one could paint so living and breathing a young woman, and know her as being Christ's mother. Later centuries imposed so great a reverence, that the simple sweetness of the San Sisto icon, its fleshly, vibrant beauty, was no longer possible.

XXII

Travelling to Rome was relatively easy, but my heart quailed at the two journeys ahead. It was a comfort to remember that these were genuinely pilgrimages, which, by tradition, were not meant to be all that easy. What was infuriating, of course, that history being different, I would only have had one pilgrimage ahead. The other two surviving icons of the Virgin had both been in the holy Monastery of St Catherine in the Sinai desert. This is the treasure house of early icons, but in the middle of the nineteenth century, a Russian scholar, the Archbishop of Kiev, Porfirii Uspenskii (1804–85), visited this monastery in the course of his pastoral journeys. He was, perhaps, the first to discover the incredible richness of early manuscripts, documents and icons that the monks had been collecting for well over a thousand years. This dignified and learned cleric, as one might expect, was both amazed and enthralled. Since the good monks had hundreds upon

hundreds of icons, he saw no reason why they should not give him a few, and so four of the sixth or seventh-century icons travelled back with him to Kiev. The monastery had two early icons of the Virgin; Archbishop Uspenskii took one.

As time progressed, it became clear that the Ukraine, dominated by a communist Russia, was not, perhaps, the safest place for religious art. There are stories that it was only the sacrificial courage of some Ukrainian historians, convincing the Russians that the icons had a documentary value, that saved them from the axe and fire which destroyed so much of the treasure of Russian religious art. The Virgin of Kiev spent some time in a *Museum of Atheism*, where the godless could laugh at the ignorant faith of their forefathers. When the sun began to shine again in the Ukraine, she was removed to the Museum of Eastern and Western Art, and it was there that I had hoped to find her.

We landed in Kiev in the midst of a heavy rainstorm which turned into a still heavier snowstorm, and it was through heavy gusts of frozen snow that we ventured out to find the museum. We found a museum; nobody could speak English, and a dispirited

journey through the galleries revealed no early icon. This was the lowest moment of all my journeys, to come so far and with such difficulty and still to fail. Fortunately, one of the party suggested that we should travel further, wondering if we had found the wrong museum, as indeed we had. A few mansions further down the road and we found what we were seeking. Here they did speak English, their faces glowed at the mention of their icon and I began a laborious ascent of a very long staircase. The Virgin of Kiev is the only one of the eight ancient icons that is in a museum. The icon in the Temple Gallery is reverently preserved, and all the others are in churches, with the lucky Virgin of San Sisto still residing, as seems her predilection, in a contemplative convent.

I knew this museum had at least one genuine masterpiece, a Valesquez portrait, and I had steeled my spirit to expect that the icon would be hanging on the wall amidst their most important paintings. But no: this small museum was fully aware of the spiritual importance of what they possessed. On what I imagine was a tiny budget, they had made a chapel for their early icons, a

small room adjacent to the general gallery, where each of the icons that Archbishop Uspenskii had brought to them, was set in a place of honour. The walls are blue because that is the sacred colour in the Ukraine and in Russia. Before each of the icons rises a wooden stand which in its details is irresistibly suggestive of a prayer stool.

Central, of course, is their great Virgin and Child, and I must confess to bursting into tears, to see it so honoured and so beautiful. [Page 101: Icon of the Virgin of Kiev, sixth or seventh century, Ukraine]. This is a unique vision of Mary, not tranquil or remote like her seven sisters, but passionate. She has snatched up the Child Jesus and holds him firmly, her eyes fixed with frightening force upon what would seem a danger that Mary alone can see. Of all the infant Christs, this is the most beautiful, a golden child, trustful and loving, [Page 102: Detail of the Child].

Mary is His protector, protecting Him against His infinite capacity to love, His guileless readiness to trust, His sweetness, His goodness. Jesus will give Himself and be destroyed. Mary does not hold Him back, but she holds Him. Who will destroy Him? It is

we who will destroy Him, we who will use God and abuse Him and finally kill Him on the Cross. Mary is urgent with the need, not to protect us, but to protect Jesus from us, to show us our own inner destructiveness.

I am aware of no icon that ventures into these dark waters, that carries such a conviction of the potential of human selfishness and the reckless readiness of God to embrace us as we are. If it kills Him, He will die loving us. All of this terrible future is made present to us in this strong and impassioned and vigorous woman. The artist has caught her in motion, not grieving as we would find in the post-iconoclast icons, but still fighting and imploring and hopeful. Every time I came back to see this icon, I found tears in my eyes. The museum, about which I cannot speak too highly, put a chair for me so I could contemplate in peace.

Before I left, of course, I looked long at Archbishop Uspenskii's other booty from Sinai. There was a wonderful, shaggy St John the Baptist, rough and impressionist – Van Gogh would have loved him. [Page 103: Icon of John the Baptist, Ukraine.] The Byzantine scholar, Kurt Weitzmann, the great

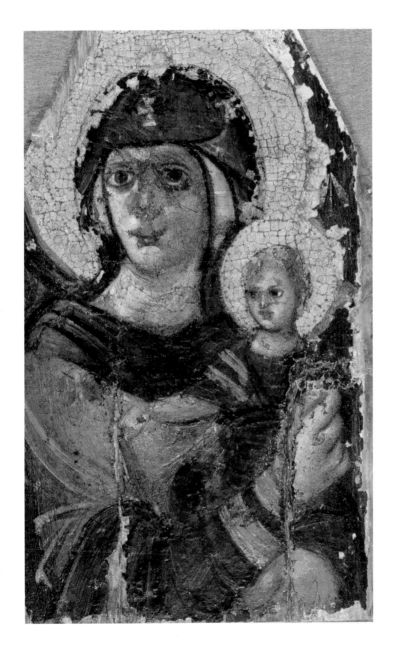

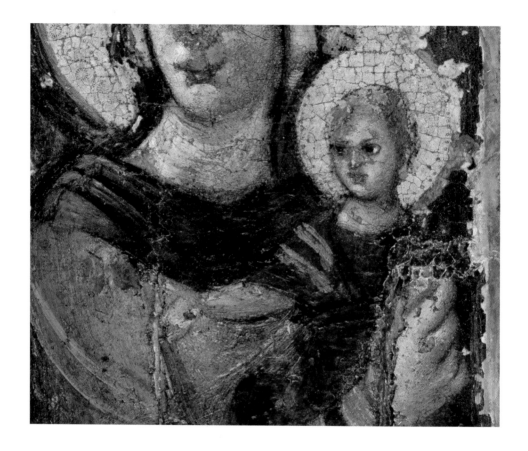

authority on the Sinai Monastery, thinks this might be a fifth-century icon, the very earliest that has survived. There is also the neat little rectangle that celebrates those great military martyrs, St Sergius and St Bacchus. They are wearing their court regalia and carrying a cross. Between them is a small medallion of

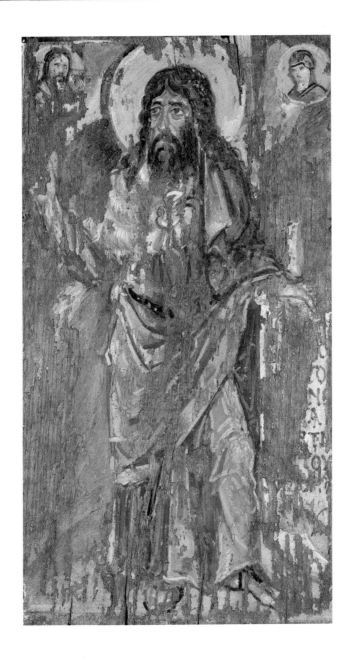

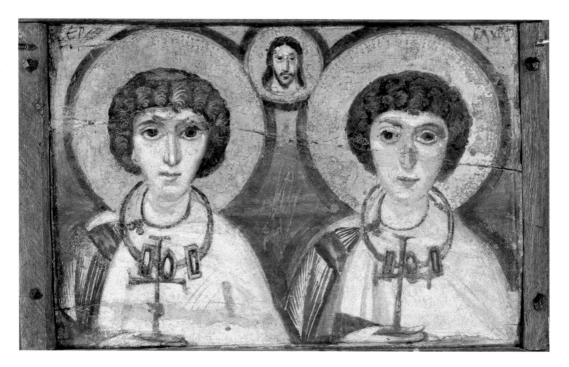

Christ, through whose grace they have triumphed over death. They were executed at the end of the third century. Their countenances may seem unexpressive, but we get a genuine sense of nobility. [Above: Icon of St Sergius and St Bacchus, Ukraine.]

In the prayerful atmosphere of this little chapel-cum-gallery, and it really is prayerful, it seemed rather irreverent to giggle, but the fourth of the Archbishop Uspenskii's icons is a glorious example of what makes early Christian art so appealing. It is a small icon of

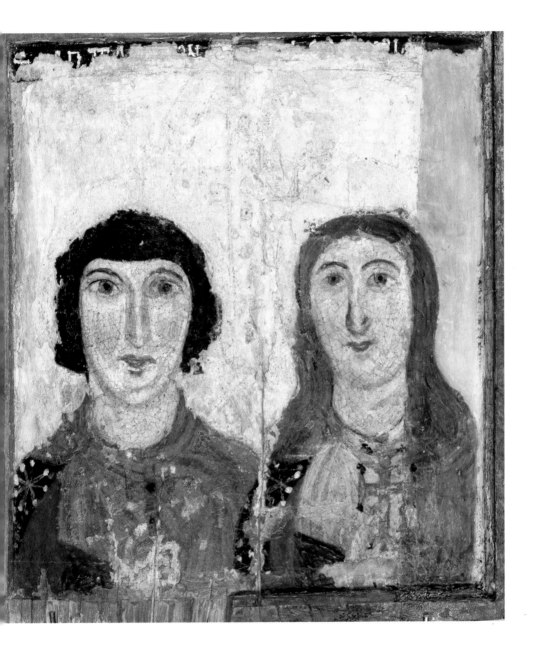

a man and woman saint and both have an air of dopey amiability that would be inconceivable after the rigours of iconoclasm. Man and woman smile out at us, daft and happy, rejoicing in their salvation, saints whose names we do not know, but who convince us that heaven is open to everybody. [Page 105: Icon of unknown man and woman saints, Ukraine.]

XXIII

If there are roughly fifty-three pre-iconclastic icons in existence, two or three in the Louvre, one or two in Berlin, a scattering in Cairo, five in Rome, one at the moment in London, at least we know where all the rest are: safely preserved in the holy Monastery of St Catherine at Mt Sinai. [Page 108: The exterior of St Catherine Monastery, Sinai, Egypt.]

Everybody who knows the Bible knows of this mountain. It was here that God gave the Ten Commandments, it was here that Moses encountered the burning bush. From the third century there have been monks praying at the foot of this mountain. The Bedouin sometimes attacked and even killed them, and so in the sixth century, the Emperor Justinian sent a troop of soldiers to build a fortress monastery. The monks have lived there ever since, an uninterrupted course of prayer, and they have become so friendly with the Bedouin, that they have

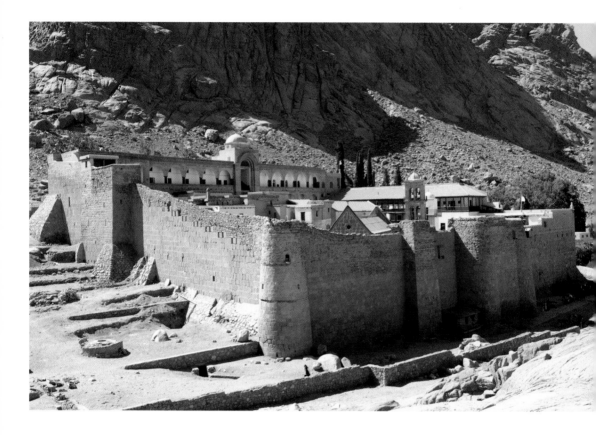

built, within the monastery, a small mosque for them to honour
God in their fashion.

Although he was not absolutely the first, the American scholar
Kurt Weitzmann, working with Princeton University and the
University of Michigan, laboured for ten years with a staff of
scholars, photographers and restorers to investigate the almost

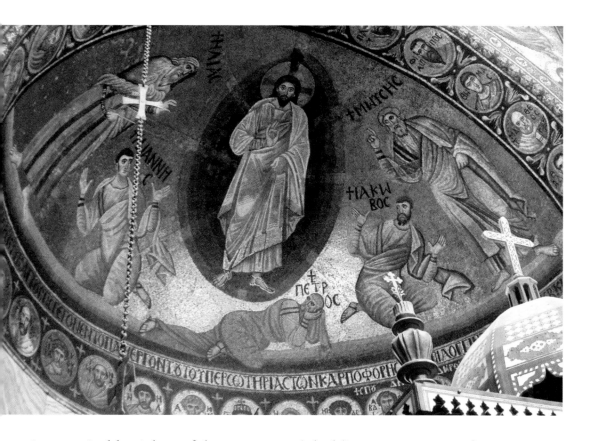

inconceivable riches of the monastery's holdings. Quite apart from
their early icons, the monastic basilica has, on its dome, a master-
work of sixth-century mosaic, depicting the Transfiguration of Jesus.
[Above: Mosaic of the Transfiguration.] This alone would make the
pilgrimage rewarding, and in the truest sense of course this was a
pilgrimage. Every journey I made to see these Holy Virgins had a

genuine aspect of pilgrimage but in no other case was the travel so hard and the conditions so difficult.

When one lands at Sharm el-Sheikh by the Dead Sea one has still ahead hours of travel through the desert, a bleak and unrewarding desert at that, with no golden sands, with only rocky outcrops and the occasional shrub. The monastery itself is of course a sacred place into which one may not venture at will. I was very lucky in that the librarian, Father Justin, gave up his time to take me through the basilica (my intense desire to see the icon was put on hold when Father Justin out of his kindness suggested I should climb the scaffolding to see the mosaic of the Transfiguration at close quarters – who could turn down such an offer, such an opportunity? I wobble even on level ground and infrequently fall over. I write with the proud sense of accomplishment in that I did manage the scaffolding and did see the extraordinary majesty of the Transfiguration face to face. But a sense of dangers dared and safely passed made the encounter with the icon of the Virgin all the more precious).

There is a small room next to the church in which the monks have hung an array of the early masterpieces that are to be found

III

nowhere else. There are three in particular that take one's breath away. First is a magnificent image of Christ the Pantocrator, Jesus the Loving Judge. [Previous page: Icon of Jesus the Pantocrator, sixth-century.] This is the earliest icon of Jesus, weighty with a sense of His divine power and His human warmth. It would give rise to countless images of the Saviour. Then there is St Peter the Apostle, shown as a man of profound authority, a living, palpable man, with his noble eyes fixed on eternity. [Opposite: St Peter.] He holds a cross in relation to his martyrdom, keys in his right hand in reference to Christ's bestowal 'of the keys of the kingdom of heaven'. Above his head, reminiscent of official Roman art, are three small medallions: Jesus in the middle with a cross behind His head, Mary to His right and a young saint, probably St John the Evangelist, on His left. It would have been privilege enough to have seen these icons, but of course, I had come primarily to see the third of their great masterpieces, that of the enthroned Virgin. [Page 115: Icon of the Enthroned Virgin, sixth century.]

Of all the early icons, this may be the most complex. Mary sits on a throne, wooden but bejewelled, and one notices that beneath

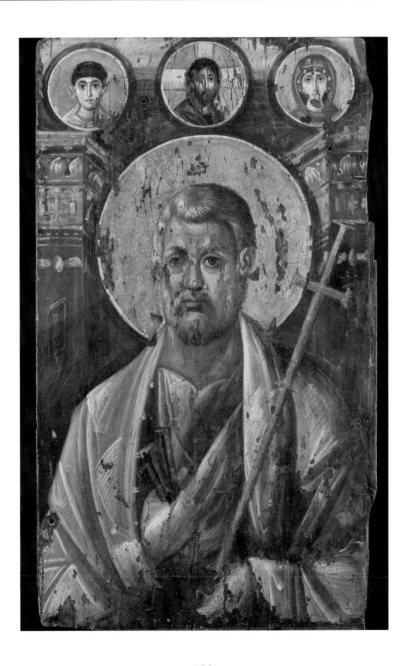

her blue robe there peeks out the small scarlet slippers that were a prerogative of the empress alone. As so often, she looks away from us, dignified and peaceful, displaying the infant Jesus who is small, gentle and appealing. This is another golden child, although not as radiant and vulnerable as the Kiev infant. On either side of her, stand two warrior saints, an older man who is universally taken to be St Theodore and a much younger soldier, who is either St George or St Demetrios. Both hold the crosses of their martyrdom and gaze straight into our eyes. Behind them, and this is very reminiscent of the Virgin of Santa Maria in Trastevere, there are two archangels, holding sceptres and looking upwards with amazement. Coming down from heaven in a path of golden light, is the hand of God, outstretched over Mary and the Holy Child. [Page 116: Detail of the hand of God, Icon of the Enthroned Virgin.]

What makes this icon so subtle is the different way in which the persons involved are painted. The two saints are almost abstracts of human beings, paper thin, inexpressive, there to announce the reality of God. Whether one is young like St George or mature

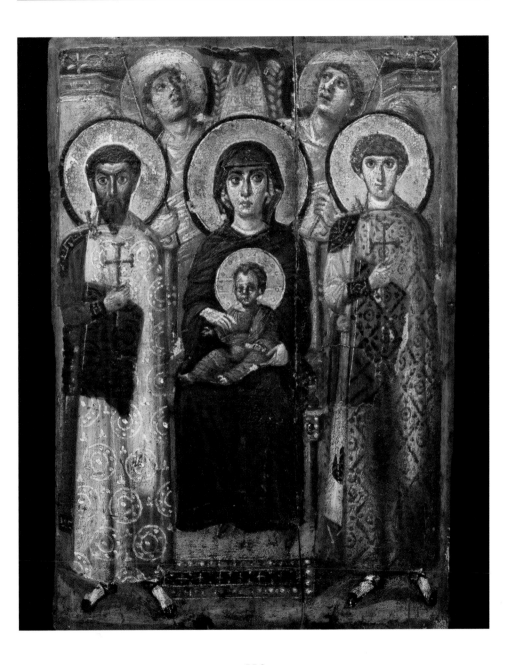

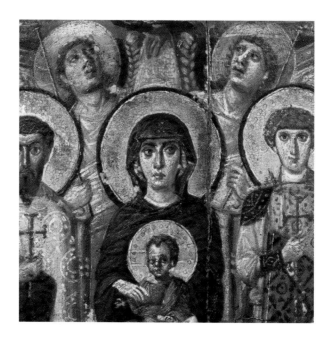

like St Theodore, God will take possession of those who will receive Him. They belong to this earthly world, but they have passed beyond it. They are human diagrams, as it were, of what it means to be a saint who is now enjoying the fullness of heaven. But the angels do not belong to this world of ours. They are transparent, ethereal, with diaphonous halos: we can see the architecture through them. Theirs is the world of heaven, and they are merely visiting here below.

But Mary and Jesus are neither abstract like the saints nor transparent like the angels. They are full, complete human beings, always here with us, so blessed by the hand of God, that they are at home in the ecstatic joy which astonishes the angels and cannot be communicated by the saints. They are at home in all worlds. If the saints are of time, and the angels are of eternity, then Mary and Jesus are of time-in-eternity (this is the same mystical vision of the icon in Santa Maria in Trastevere). For them, ecstasy is so familiar, so much their natural environment, that they can retain all the flexibility and colour of what we think of as normal living without losing, for a moment, their absolute union with God. The hand of God, that so astonishes the angels, has become translated, through the Incarnation, into the small fleshly hand of the infant Jesus. This icon is a meditation on the inconceivable mystery of what it means for God to become human.

XXIV

I am loath to leave these eight icons. There are two unforgettable images of the child Jesus, the sweet, loving, beautiful child of Kiev, [Opposite, top left] and the intense, anxious little Jesus of London [Opposite, top right]. The searching and imaginative poetry of early Christendom has given us two exceptionally human Virgins, the serene beauty of San Sisto and the strong impassioned Mother of Kiev. [Opposite below left and right.] Two of the icons dwell on Mary's status as Mother of God, the tall empress of Trastevere and the seated Queen in Sinai. [Page 120 top right and left.] To me, the loveliest of the Virgins are the gentle, swan-necked, London image, and the exquisite and mutilated Virgin of Santa Maria Nova. [Page 120 below left and right.]

What strikes me powerfully, is that though some of these Virgins have a touch of sternness, or seem lost in their own reflections (the Pantheon Virgin comes to mind), yet none of them

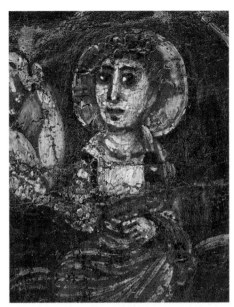
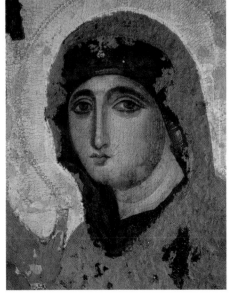
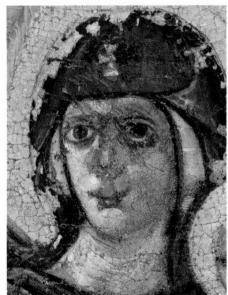

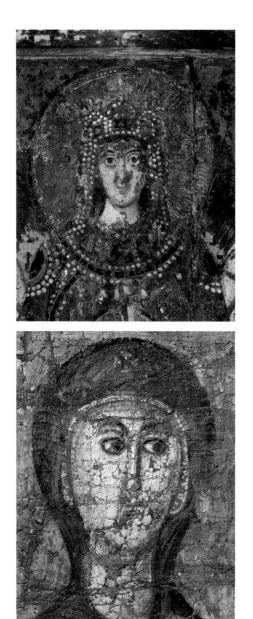

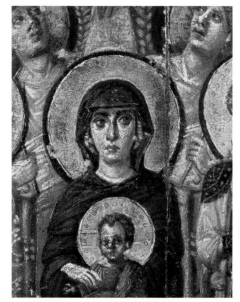

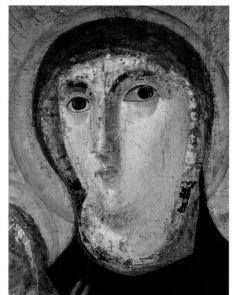

are sad. In post-Iconoclasm, nearly every icon of the Virgin seemed shadowed, however gently and tenderly, by an awareness that her Son will be crucified. There are few smiling Virgins. But, if we extend our definition of icon past 'painted on panels of wood' and consider frescoes, mosaics, ivories and book illuminations, the early centuries show us a radiant Mother of God that somehow Christianity has lost sight of.

We cannot go back in time and live in the wonder and vulnerability of those early centuries. God is waiting for each of us in our own century, equally vulnerable but perhaps lacking in the sense of wonder. All too easily our religion can seem cut and dried, a matter of dogma. It is there in the books, the thousands upon thousands of books that explore the depths of our faith. Even if we do not read these books, we know them, and we take our knowledge into our big settled churches, where everything can seem – I say this with horror – ordinary or even dull. Nothing is less boring than loving God. Many contemporary Christians may struggle to accept this but unless the certainties of our twentieth-century faith are irradiated with the light that we see in

the faith of the early Christians, we run the risk of not appreciating what it is to live in Jesus.

These early images seemed to me to have the power to shock us out of this complacency, to make us look anew at what the birth of Jesus meant, and means. These images, these icons, are 'art', yes, but infinitely more. They are potentially revelations, encounters. Strangely, or perhaps (considering Iconoclasm) it is only to be expected, these images are few.

When I was searching for a title for this book, a friend suggested, 'The Lost Virgins'. But, of course, these Virgins are not lost. In both Santa Maria Maggiore and Santa Maria in Trastevere, the icons are splendidly visible, not only to the multitudes of tourists who throng Rome, but to their respective congregations. These icons are seen, valued and loved. The *Virgin of Kiev* is very visible to those who travel to the Ukraine, and so is the Virgin of Mt Sinai to those who make the still longer journey to the Sinai desert. Even the other four are not actually lost, just difficult to see.

But there are, in fact, two Virgins that are truly lost, two pre-Iconoclastic images of Our Lady, hidden away in the

Monastery of St Catherine at Mt Sinai (where else?). These are two semi-destroyed icons, so ravaged and mutilated that they are not considered worthy of being recognized for what they are. One is a seventh-century Virgin of Intercession. Like the gentle Virgin of San Sisto, cherished still by contemplative nuns, this Virgin holds no infant Jesus. Little is left of her except a hand and the lower part of a sweet and earnest face. She seems to be holding an open scroll spelling out the supplications she is offering on our behalf. We can still see that her head with its dark veil, is bent, and even what remains of the figure has a grace and sweetness that touches the heart.

The other sixth or seventh-century Virgin is in a far worse state with little remaining. There is just enough to show us that this Virgin too, like the beautiful London icon, held her Son in a mandorla, which makes us long to see what the early Christians saw, and respond to the icon as it deserves.

Anyone who has been privileged to have seen these ancient icons of the Virgin, will have realized that they have encountered something greater than an image. I have called it an encounter

with God, because that is truly what it was for me, and what I hope it will be for you, too.

I am very grateful for the affectionate and practical help I have received from my friends Marjorie Weeke, Annie Frankel and Fr Rod Stephens.

BIBLIOGRAPHY

This is not a full bibliography, but for those who would like to read further, these are the books I have found most helpful.

EARLY CHRISTIAN ART

Picturing the Bible, 2007, Kimbell Art Museum, Ft. Worth, TX

Age of Spirituality, 1977, Metropolitan Museum, New York City, NY

BYZANTINE ART

Byzantine Art, 2000, by Robin Cormack, Oxford University Press

Early Christian and Byzantine Art, 1997, by John Lowden, Phaidon Press

Byzantine Art in the Making, 1976, by Ernst Kitzinger, Harvard University Press

MONASTERY OF ST CATHERINE

The Holy Monastery of St. Catherine at Mt. Sinai, Icons from Sinai, 2006, Getty Museum, Los Angeles, CA

Icons from the Monastery of St. Catherine at Mt. Sinai, 1976, Kurt Weitzmann, Princeton University Press

COPTIC ART

The Treasures of Coptic Art, 2006, by Gawdat Gabra and Marianne Eaton-
Krauss, The American University in Cairo Press

MARY THE MOTHER OF GOD

The Virgin Mary, Mother of God, 2000, edited by Maria Vassilaki, Skira
Publishers

Images of the Mother of God, 2005, edited by Maria Vassilaki, Ashgate
Publishing

GENERAL STUDIES

Figure and Likeness, 2002, by Charles Barber, Princeton University Press

Likeness and Presence, 1994, by Hans Belting, University of Chicago Press

IMAGE ACKNOWLEDGEMENTS

Page 3:

Mother and Child from Santa Francesca Romana, Rome. © 1990 Photo
Scala, Florence/ Fondo Edifici di Culto.

Mother of God of Tenderness of Vladimir (Eleosa). Moscow, Tretyakov State
Gallery. © 1990 Photo Scala/ Florence.

Page 15:

Synagogue Wall Painting, Dura-Europos. © Yale University Art Gallery

Page 17:

Baptistry Wall Paintings, Dura-Europos. © Yale University Art Gallery

Page 19:

Catacomb of Callixtus, third-century Rome. © Pontifical Commission for
Sacred Archaeology.

Pages 22, 23, 24, 25

Jonah Swallowed. Asia Minor, probably Phyrygia (central Turkey), Early

Christian, c. 270–280. Marble, 51.6 x 15.55 x 26.2 cm. The Cleveland Museum of Art. John L. Severance Fund 1965.237.

Jonah Cast Up. Asia Minor, probably Phyrygia (central Turkey), Early Christian, c. 270–280. Marble, 40.65 x 21.6 x 37.6 cm. The Cleveland Museum of Art. John L. Severance Fund 1965.238.

Jonah Under the Gourd Vine. Asia Minor, probably Phyrygia (central Turkey), Early Christian, c. 270–280. Marble, 32.1 x 46.3 x 17.5 cm. The Cleveland Museum of Art. John L. Severance Fund 1965.239.

Jonah Praying. Asia Minor, probably Phyrygia (central Turkey), Early Christian, c. 270–280. Marble, 47 x 14 x 20.6 cm. The Cleveland Museum of Art. John L. Severance Fund 1965.240.

Page 26:

'Noah', from the catacomb of Priscilla. © Pontifical Commission for Sacred Archaeology.

Page 27:

Lamp with Good Shepherd, Noah's Arc, third century.

Page 31:

Fresco of Mother and Child, catacomb of Priscilla, mid-fourth century. © Pontifical Commission for Sacred Archaeology.

Page 32:

Fresco of the Adoration of the Magi, catacomb of Marcellinus and Peter, early fourth century. © Pontifical Commission for Sacred Archaeology.

Page 33:

Adoration of the Magi, marble sarcophagus, mid-fourth century, Museum of Antiquities, Arles, France.

Page 34:

Sarcophagus with dry bones and adoration, early fourth century, Vatican Museum, inv. 31450. Photo William Storage.

Page 35:

Sarcophagus of Junius Bassus, Vatican City, Rome, © Fabrica Di San Pietro in Vaticano.

Page 40:

Mandylion from San Silvestro in Capite, sixth century.

Page 42:

St Veronica's Veil, Alte Pinakothek, Munich, Germany. © Bildarchiv Preussischer Kulturbesitz.

Page 46:

Icon of Triumph of Orthodoxy, from Constantinople, Byzantine, around
1400. © The Trustees of the British Museum.

Page 53:

Icon of Mother and Child, before and after cleaning, sixth or seventh
century, Egypt. Reproduced by kind permission of Dick Temple at the
Temple Gallery, London.

Page 65:

Photo of the interior of the Pauline Chapel, Basilica Santa Maria Maggiore,
Rome. © Foto Gioberti S.r.l.

Page 67:

Icon of Virgin and Child, Santa Maria Maggiore, Rome. © Foto Gioberti
S.r.l.

Page 70:

i. Santa Maria Maggiore – Annunciation to Mary – Mosaic, early Christian,
432–44. Triumphal Arch, left side. Photo: akg-images/Nimatellah. Ii. Santa
Maria Maggiore – The Adoration of the magi with Maria Ecclesia and
synagogue; detail: middle group. Mosaic, early Christian, 432–44.
Triumphal Arch, left side. Photo: akg-image/Nimatellah.

Page 73:

Madonna della Clemenza, sixth-seventh century. Rome, Church of Santa
Maria in Trastavere. © 1990. Photo Scala, Florence.

Page 80:

The Pantheon, Rome, © iStock.

Page 83:

Icon of Santa Maria ad Martyres, Rome. Photo © B.N. Marconi, Genova.

Page 89:

Mother and Child from Santa Francesca Romana, Rome. © 1990 Photo
Scala, Florence/ Fondo Edifici di Culto.

Page 93:

Madonna of San Sisto. Photo © B.N. Marconi, Genova.

Pages 101, 103, 104, 105:

Icons, The Virgin and Child, Saint John the Baptist, Saints Sergius and
Bacchus, The Saints. © The Bohdan and Varvara Khanenko Museum of
Arts, Kiev, Ukraine.

Page 108:

Photo of exterior of St Catherine's Monastery, Sinai, Egypt. © iStock.

Pages 109, 111, 113, 115, 116:

Mosaic of the Transfiguration of Jesus; Icon of Jesus the Pantocrator; Icon of St Peter; Icon of the Enthroned Virgin, sixth century. By permission of St Catherine's Monastery, Sinai.